A CRETAN STATUETTE
IN THE
FITZWILLIAM MUSEUM

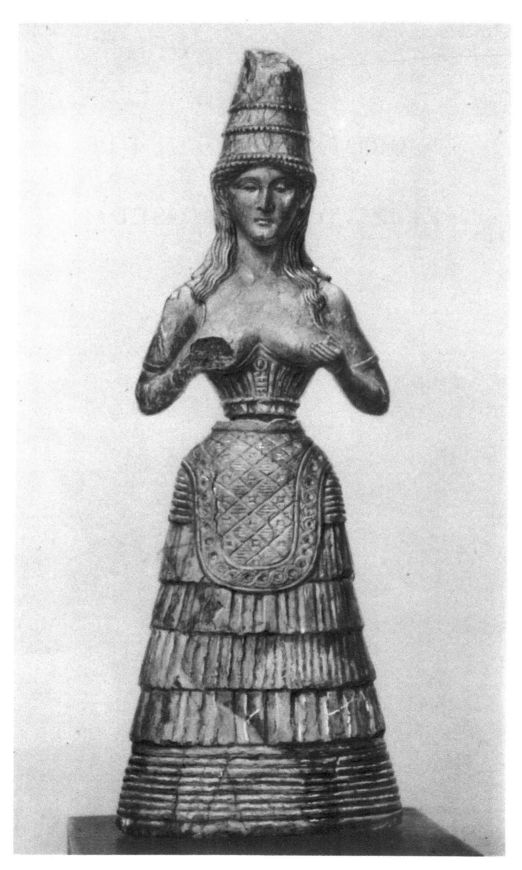

CRETAN STATUETTE IN THE FITZWILLIAM MUSEUM. (Scale 1 : 1.)

A CRETAN STATUETTE
IN THE
FITZWILLIAM MUSEUM

A STUDY IN MINOAN COSTUME
BY
A. J. B. WACE

CAMBRIDGE
AT THE UNIVERSITY PRESS
MCMXXVII

CAMBRIDGE
UNIVERSITY PRESS

University Printing House, Cambridge CB2 8BS, United Kingdom

Published in the United States of America by Cambridge University Press, New York

Cambridge University Press is part of the University of Cambridge.

It furthers the University's mission by disseminating knowledge in the pursuit of education, learning and research at the highest international levels of excellence.

www.cambridge.org
Information on this title: www.cambridge.org/9781107664388

First published 1927
First paperback edition 2014

A catalogue record for this publication is available from the British Library

ISBN 978-1-107-66438-8 Paperback

PREFACE

ALTHOUGH the excavations in Crete, and at Mycenae and other centres of the great Bronze Age culture of Greece have yielded exceedingly rich finds of objects of metal, pottery and other materials they fall behind Egyptian excavations in one respect, for so far no actual Minoan or Mycenaean textiles have been found, as the conditions are unfavourable for their preservation. Our knowledge of them therefore depends on our interpretation of the contemporary illustrations of costumes and the like in statuettes, wall paintings, or gold work. The important statuette recently acquired by the Fitzwilliam Museum and here published has thus an added value and this booklet is an attempt to discuss some aspects of Minoan feminine costume by the light of this and other extant monuments.

My sincerest thanks are due to the generous donor, who wishes to remain anonymous, for the gift which has provided the plates of the Fitzwilliam statuette and the other illustrations. I would also thank the Managing Committee of the British School at Athens for kind permission to reproduce illustrations from their *Annual*, the Liverpool University Press for the loan of the block of the girdle of Rameses III, Dr Zahn for photographs of the Berlin bronze statuette, Dr Caskey for photographs of the Boston ivory, Professor Karo for permission to copy illustrations from *Tiryns* and Dr C. A. Boethius for reading the proofs. The Reale Accademia dei Lincei and the Society for the Promotion of Hellenic Studies have generously allowed me to reproduce illustrations from *Monumenti Antichi* and from the *Journal of Hellenic Studies*. Professor Nilsson has most courteously allowed me to read the proofs of his forthcoming book on *The Minoan-Mycenaean Religion*, Dr Rastall has kindly identified the material of the statuette, and Mr C. T. Seltman, Mr J. Penoyre, Dr Xanthoudides, Miss Lorimer, Miss Murray, and Mr P. de Jong have unselfishly helped in many ways.

Modern Greek names have been transcribed according to the system of the Royal Geographical Society, except to avoid misunderstanding in such cases as Stais and Maraghiannis who so sign themselves in their works published in languages other than Greek.

A. J. B. W.

LONDON
May 1927

CONTENTS

ILLUSTRATIONS

PLATES

TEXT-FIGURES

I

PROVENANCE AND TECHNIQUE

PLATE II

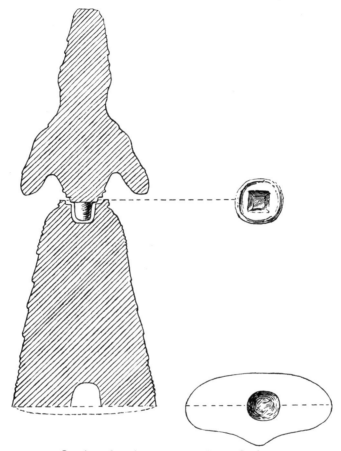

1. Section showing construction. (Scale 1 : 2.)

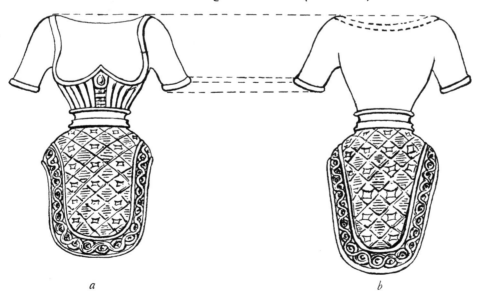

a *b*

2. Front (*a*) and Back (*b*) of bodice and apron. (Scale 3 : 4.)

DETAILS OF CRETAN STATUETTE IN FITZWILLIAM MUSEUM

I. PROVENANCE AND TECHNIQUE

THE circumstances of the discovery and the exact provenance of this important statuette are both unknown. The first news of it was a bazaar rumour in Athens, but the statuette made its way direct from Crete to Paris whence it was acquired for the Fitzwilliam Museum. It is said to have been found in Crete not far to the east of Candia and a more recent report states that it came from the ruins of the harbour town of Knossos which lay on the sea close to the mouth of the river Kairatos. As the figure is discoloured and was broken into several pieces, the right arm being badly splintered, it would seem that it was found in the ruins of some building, perhaps a shrine, which had been destroyed by fire.

The figure, though broken, is practically perfect except for part of the right hand and forearm and a small fragment from the top of the headdress. It stands ·227 m. high and is of an inferior quality of marble, common in Crete, which unlike the Cyclades is not rich in good marble. The marble figurines of the Early Bronze Age found in Crete are of Cycladic marble and therefore almost certainly importations.[1] This statuette which belongs to the Late Bronze Age, being of a material typically Cretan, must be regarded as undoubtedly of Cretan workmanship. In its execution the most striking point is that it is composed of two pieces of marble worked separately and carefully fitted to one another.[a] The division, as would be expected, occurs at the waist where the upper part of the body ends in a rounded peg. In the upper part of the skirt a round hole was bored by a hollow drill and then chiselled to a rectangular shape. At the upper edge of the resulting socket another hole was drilled of greater diameter and much shallower than the other. This makes a kind of low raised edge which when the two pieces are put together hides the lower line of the upper part of the body, and also most appropriately forms the waist belt of the costume. When the two pieces were adjusted to one another the joint would be made secure either by pressing the peg at the bottom of the upper part of the body into a small lump of clay placed in the socket or by inserting into the socket a rectangular plug of wood with the centre bored out. In the latter case when the two pieces were set together the wood would be wetted and would swell so as to hold the two portions securely together. This method of making a statuette in two separate sections

[a] *Plate* II, 1

[1] Evans, *Palace of Minos*, I, 115.

which were afterwards fitted together seems to have been adopted by the sculptor from the coroplast. The terracotta votive figurines of women found at the hill sanctuary of Petsophas, near Palaikastro, were similarly made in two pieces joined at the waist. Professor Myres in his account of them[1] says that the skirt has nearly the form of a common beaker vase of Palaikastro, but baseless and inverted and in one example with a moulding round the apex. "Into this apex was thrust the upper part of the body which was moulded separately and ended in a long peg for securer junction with the skirt piece."[a] It is not known whether the somewhat similar female figurine from Khamaizi[2] was also made in two pieces and then set together, but the same process is observable in other terracotta figures made in Crete at a much later period. The four female figurines from Palaikastro showing a lyre player and three dancers, which date probably from Late Minoan III *a*, were made in a similar way. Professor Dawkins[3] says: "Like the Petsofa figures they were made in two parts, the upper half ending below in a peg which was inserted into the top of the skirt piece." It is quite possible that the majority of the female terracotta figurines were similarly composed of two separate pieces set together, but careful examination of the originals in the Candia Museum is needed to verify this.

At any rate it will be seen that this system of making terracotta figurines was practised by the coroplasts in East Crete from Middle Minoan I to the beginning of Late Minoan III and so it is not at all surprising to find that a sculptor should have been so influenced by terracotta models.

The chryselephantine Snake Goddess at Boston is also composed of two pieces of ivory set together, though there the junction occurs about half-way down the skirt.[4] Still there again the joint is secured by inserting a rectangular projection at the back of the lower part into a corresponding socket cut in the upper part of the skirt. This is further proof that it was by no means the custom in Minoan Crete to make a statuette, whatever the material, out of one piece.

[a] *Plate* VI, 3

[1] *B.S.A.* IX, 367.
[2] Xanthoudides, ʼΕφ. ʼΑρχ. 1906, p. 138, Fig. 4; Maraghiannis, *Ant. Crétoises*, II, Pl. XXXIV, 6.
[3] *B.S.A.* X, pp. 217 ff.; Bosanquet-Dawkins, *Unpublished Objects*, p. 88, Fig. 71.
[4] Caskey, *A.J.A.* 1915, pp. 238 ff., Pl. XVI.

In yet another point the Fitzwilliam statuette recalls the terracotta figurines of Palaikastro. In its base[a] is a small hole (·013 m. deep and ·016 m. wide) cut [a]*Plate* II, 1 out by a hollow drill, and after the drilling was finished the resulting core was snapped off. The roughness of the surface at the bottom of the drill hole can still be felt. The purpose of this hole was no doubt to serve as a socket for some form of peg so that the statuette could be firmly fixed on a base. If so fixed it may well have been set up in conjunction with other figures so as to make a group not unlike that which the Snake Goddess and her votaries of the Knossian temple repositories are believed to have made.[1] With the Palaikastro figurines part of a circular clay base in the form of a flat ring was found. This, if it did not belong to these figurines, at all events seems to have belonged to a similar set. The figurines seem to have been attached to such a base because, as Professor Dawkins says,[2] "their skirts just at the back are pinched over to grip the edge of a probably circular base." This case is clearly analogous to the Fitzwilliam statuette, although different methods of attaching the figures to the base were employed.

[1] Evans, *Palace of Minos*, 1, 518, Fig. 377.
[2] *B.S.A.* x, 219; cf. Bosanquet-Dawkins, *op. cit., loc. cit.*

II
DESCRIPTION AND COSTUME

PLATE III

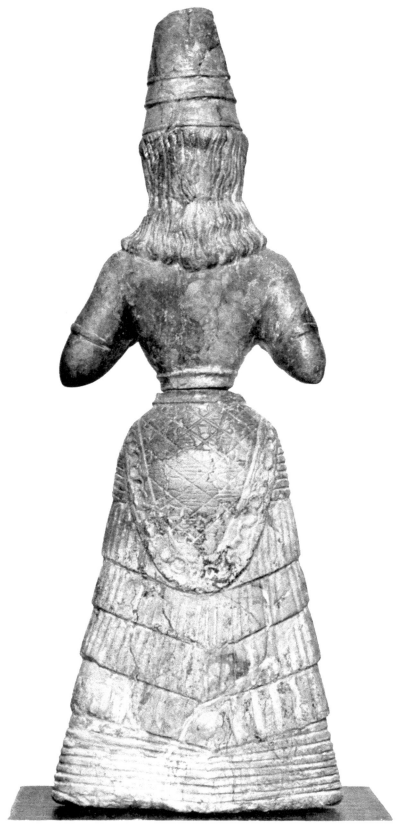

CRETAN STATUETTE IN THE FITZWILLIAM MUSEUM. (Scale 1 : 1.)

II. DESCRIPTION AND COSTUME

THE costume is clearly rendered and most interesting in its details, which vary in some points from other figures of about the same date and style. On the head is a tall flat-crowned hat in three tiers which diminish in circumference towards the top and give it a turban effect. Part of its top is broken away and the lower edge of each tier is decorated with a narrow binding beaded in front and plain behind. The hair is brushed back from the centre of the forehead to the sides in twelve wavy strands. Two fall down in front onto the shoulders, one on either side, and ten rather shorter hang down the back of the neck. The dress itself apparently consists of three pieces, bodice, skirt, and apron. The bodice[a] is unornamented and well fitted to the figure at the back, covering the shoulders and the forearms to just above the elbow. The sleeves do not seem to have been set in separately. It is finished at the edges with a narrow flat binding. In front it is cut very low on a wide curve so as to expose both breasts which are full and matronly. Under the breasts it must be boned, for it stands up without any visible support and there are vertical incised lines which would seem to mark the positions of the bones. The lines are straight and not curved as they would be if produced by the tight fitting of an unboned garment. The "bones" cannot of course have been whalebone, but may have been of wood or perhaps even of bronze, in which case they would be analogous to the European iron corsets of the XVIIth century. The bodice is fastened together in front on a vertical straight line running upwards to form a triangular point between the breasts. To produce this effect a stiff central piece is necessary. There is no definite sign of a central bone and hooks and eyes set on a stiff backing can hardly have been employed. At the top of the junction is a round object suggesting a brooch, buckle, or large button. Below this are rectangular divisions set horizontally, and the alternate divisions have a vertical incision across their middles. This suggests that the fastening may have been effected by a braid looped in and out from side to side. Then a metal pin with a knob of the same material or of stone was inserted at the top and passed downwards over and under the bands of braid. This would produce the effect of the vertical lines on the alternate divisions and also be stiff enough to support the fastening of the bodice in the triangular peak between the breasts. Perhaps instead of a band of braid or some similar material the fastening through which the pin was

[a] *Plate* II, 2

W 2

thrust might have been some form of buckle or clasp of metal[1] (gold, silver, or bronze), or perhaps even of boar's tusk, which could be secured by a pin inserted somehow as suggested above. Some of the ornamental pins of peculiar shape which have been found in tombs either in Crete or on the mainland may have been used for the purpose suggested. The magnificent gold pin with a silver shank from the Third Shaft Grave at Mycenae[2] would have been well adapted for this and so also would the gold pin from the Isopata Tomb near Knossos[3] and those like it from Gournia.[4] The long straight pins with heavy knobs[5] of gold or crystal are less likely to have been employed in this way. In the first place a pin with a curved head is much more suitable and the straight pins are too long. They are much more likely to have been used in pinning together a cloak or some similar garment in much the same way as the analogous metal pins of the later Geometric and archaic classical period were used.[6] A straight pin also could not be so easily inserted and if inserted its knob would press against the body and cause discomfort which would be avoided if the ornamental head of the pin curved outwards away from the body.

The skirt is long and bell shaped and so must have been cut with considerable flare and with its lower edge curved and not straight. The foundation has eight rows of horizontal tucks or cording just below the waist line and nine more such rows at the very bottom.[7] Between the two groups of tucks four horizontal pleated flounces of uniform width are attached to the foundation. The upper edge of the top flounce is set just underneath the lowest tuck of

[1] As, for instance, in the bracelet of Princess Nabhotep (XIIth Dynasty), de Morgan, *Dachour* 1894, p. 114, Pl. xxxvii. [2] Schliemann, *Mycenae*, p. 193, Fig. 292.

[3] Evans, *Prehistoric Tombs*, p. 151, Fig. 129.

[4] Boyd-Hawes, *Gournia*, Pl. iv, 40–42; Hastings, *A.J.A.* 1905, pp. 278 ff.

[5] *E.g.* Schliemann, *Mycenae*, p. 201, Figs. 309, 310.

[6] *E.g.* Droop, *B.S.A.* xiii, pp. 109 ff. Cf. Müller, *Jahrbuch* 1915, pp. 299 ff.; he, however, thinks the curved pins were for a *peplos*.

[7] Rodenwaldt (*Tiryns*, ii, 77) seems to prefer the suggestion that the horizontal lines on the skirt of the faience Snake Goddess from Knossos (Evans, *Palace of Minos*, i, pp. 501, 523, Fig. 382), if correctly restored on the model of a fragment, are in-woven designs and not tucks or cording. It would be practically impossible to weave that design with its border so as to be truly horizontal when the stuff was made up, because the lower edge of a bell-shaped skirt is curved and not straight, and the side seams are bias. See further below, pp. 29, 34, Fig. 2.

PLATE IV

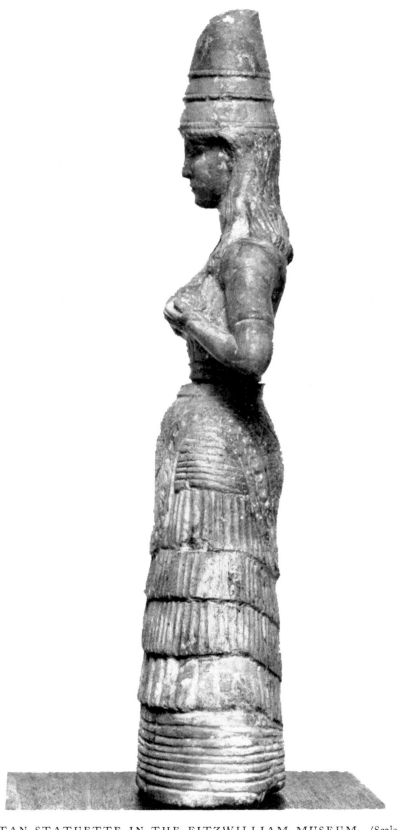

CRETAN STATUETTE IN THE FITZWILLIAM MUSEUM. (Scale 1 : 1.)

PLATE V

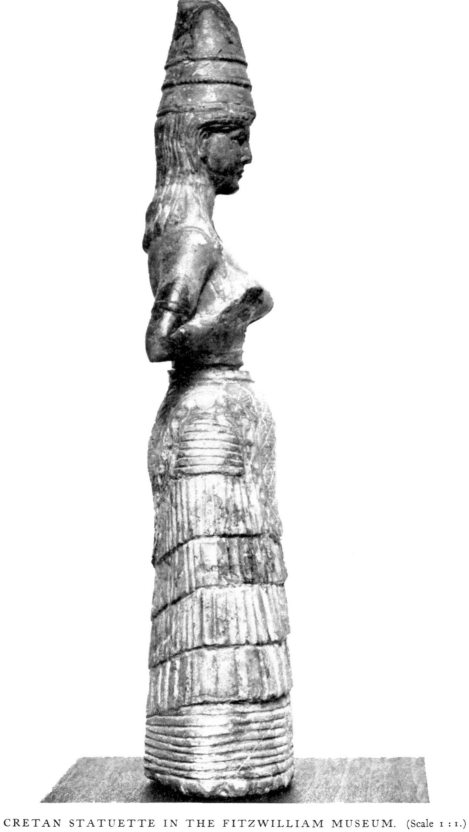

CRETAN STATUETTE IN THE FITZWILLIAM MUSEUM. (Scale 1 : 1.)

the upper group, and similarly the other flounces below are set with their upper edges just underneath the lower edge of the flounce immediately above. In front and at the sides the flounces are horizontal, but in the centre of the back, where presumably the two ends were joined, they dip to form a V-shaped point. The top flounce has fine side pleats, the second fine side and box pleats alternating, the third fine side, and the fourth box pleats only. At the waist is a kind of double apron[a] covering the upper part of the skirt both front and back, but not at the sides. It has no visible fastening and seems to be in one piece and is shorter in front than behind.

[a] *Plates* I–V

One cannot see how the apron would have been put on unless there was some fastening at the side. Lady Evans suggests[1] for the similar garment of the Knossian faience Snake Goddess[b]: "It is not improbably cut as an oval and the head inserted through a hole in the middle as in the modern poncho". In this case, however, the hole in the middle would have to be large enough to pass over the shoulders as well and then could not fit snugly round the waist. As regards the apron on the faience votary from the Knossian Temple Repositories she suggests that there was a fastening on each hip.[2] This seems much more likely, but there is no certain trace of it in the Fitzwilliam statuette. The skirt too must be fastened at the waist, probably with a placket which would be concealed by the apron. The outline of the apron is curved and so must be shaped with a bias at the hips, for otherwise it could not fit tight round them without pleats. It is bordered[c] with a design of interlacing serpentine lines so arranged as to form a continuous row of circles within them. The circles are slightly sunk, probably by drilling and the serpentine lines are broad. The whole design is edged with raised plain bands on either side. Within this there is a diaper or net pattern in which the compartments are decorated alternately with horizontal hatchings or rather irregular diamonds. As Lady Evans says[3] with reference to the somewhat similar design on the apron of the Knossian votary (Fig. 2), the effect is that of a check set obliquely or a small plaid, used of course diagonally. Round the waist is a belt or girdle, perhaps of metal or more probably of linen, not unlike the girdle of Rameses III[4][d] with ornaments of gold like the girdle of the "princess" in the tomb at Dendra.[5]

[b] *Plate* VII

[c] *Plate* II, 2

[d] *Plate* XII

[1] *B.S.A.* IX, 80. [2] *Ibid.* p. 81. [3] *Ibid.*

[4] Lee, *Liverpool Annals*, v, pp. 84 ff., Pl. XI.

[5] Persson, *Art and Archaeology*, XXII, 233. Homeric girdles were ornamented with gold; Seymour, *Life in the Homeric Age*, p. 166.

III

ANALOGOUS ILLUSTRATIONS OF COSTUME

PLATE VI

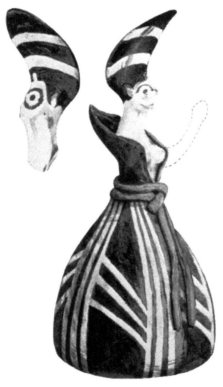

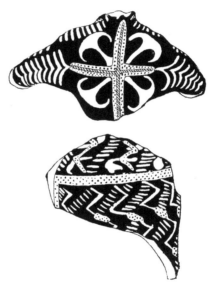

1. RECONSTRUCTION OF TERRA-
COTTA FIGURINE FROM PET-
SOPHAS. (Scale 1 : 2.)

2. FRAGMENTS OF TERRACOTTA
FIGURINE FROM PHYLAKOPĒ.
(Scale 1 : 1.)

3. BODY OF TERRACOTTA FIGURINE
FROM PETSOPHAS.

(After *B.S.A.* IX, Pl. XI, 22 : no scale given.)

III. ANALOGOUS ILLUSTRATIONS OF COSTUME

THIS leads us naturally to consider the other Minoan and Mycenaean figures or illustrations of costume that are in any way analogous, especially the faience figures of the Snake Goddess[a] and her votaries from the Temple Repositories at Knossos,[1] the chryselephantine statuette of the Snake Goddess at Boston,[2][b] and the frescoes from Agia Triada,[3][c] Thebes,[4] and Tiryns.[5] Older than any of these are the votive terracotta figurines of women from the hill sanctuary of Petsophas[d] near Palaikastro, which date from Middle Minoan I.[6] The costume of these naturally marks an earlier stage in the evolution of dress and may help us to understand the fashions of the later times. The women of Petsophas, so far as the type can be restored from the numerous broken specimens found, seem to be wearing a one-piece costume. On their heads they wear a tall peaked cap projecting slightly forwards, and round it are two white bands which may indicate divisions. If so it would be a three-tiered cap or hat similar to that of the Fitzwilliam statuette. The one-piece frock has sleeves reaching to the elbow and a high Medici collar covering the neck and shoulders, but is left open in front with a deep V reaching to the waist. At the waist it is held in with a rolled sash which winds twice round the body and falls with two long ends down the centre of the front of the skirt. The ends of the sash may have been used to cover a placket, for which the centre of the skirt front just below the opening of the bodice would be the natural place. The sash ends of the bronze Snake Goddess in Berlin[e] fall down the centre of the skirt front[7] and may also have been used to hide a placket. The skirt is long and bell shaped and stands out well all round. It is ornamented with groups of three white lines which run down from the waist to the hem. About half-way down they are joined by groups of three oblique white lines which much suggest the V-shaped flounces on the later

[a] *Plate* VII
[b] *Plate* VIII
[c] *Plate* X
[d] *Plate* VI, 1
[e] *Plate* IX

[1] *B.S.A.* ix, pp. 74 ff.; Evans, *Palace of Minos*, I, Frontispiece, pp. 500 ff.

[2] Caskey, *A.J.A.* 1915, pp. 237 ff., Pls. x–xvi.

[3] *Mon. Ant.* xiii, 59, Pl. x.

[4] ’Αρχ. Δελτίον, iii, 339, Fig. 193.

[5] Plate XIII, 1, Rodenwaldt, *Tiryns*, ii, pp. 69 ff., Pl. viii.

[6] *B.S.A.* ix, pp. 367 ff., Pl. viii; Evans, *Palace of Minos*, I, 153.

[7] Bossert, *Altkreta*², Figs. 131, 132; *Zeit. bild. Kunst.* xxxii, pp. 65 ff.

costumes. If these are flounces perhaps the vertical white lines indicate the seams of the different sections of the skirt. So far as can be seen the dress of the Middle Minoan II *b* figurine[a] from Phylakopē[1] was similar but elaborately decorated, and the Khamaizi figurine[2] repeats the type in a simpler and more primitive form.

[a] *Plate* VI, 2

The faience figures from Knossos, which are Middle Minoan III, come next in date and consist of (*a*) the Snake Goddess, (*b*) a votary, (*c*) a fragment of the lower part of another, and (*d, e*) two votive dresses and two girdles.

[b] *Plate* VII

(*a*) The Snake Goddess[3] was found in fragments and is considerably restored.[b] Part of the top of the headdress with the snake's head, the neck with all the lower part of the hair behind, the left arm and practically all the skirt and apron except for several fragments of the latter are modern. She wears:

(1) A high cap which apparently is made of a piece of thick cloth wound spiralwise so that it seems to be in three tiers. This and the cap of the Fitzwilliam statuette may have been made like turbans.[4]

(2) A tight-fitting bodice which covers the shoulders and has sleeves reaching to the elbow. It is cut low in front on a wide curve leaving the neck and both breasts quite bare, and is fastened in the middle in front by laced cords tied in bow-like knots. As the edges of the garment at the fastening stand up straight they must presumably have been supported in some way, most probably by metal much as suggested in the case of the Fitzwilliam statuette. This bodice is decorated behind, on the sleeves and at the sides with spiraliform designs which were probably adapted to its shape. This recalls the rayed floral pattern with chevrons extending down the arms on the back of a fragmentary M.M.II terracotta figurine[c] found at Phylakopē in Melos.[5] This, so far as its costume can be discerned from the two extant pieces was of the same type as the Petsophas figurines which are slightly earlier in date (M.M.I). It does, however, provide a connecting link between these M.M.I terracotta figurines and the Knossian faience figures which belong to the later phase of M.M.III.

[c] *Plate* VI, 2

(3) A double apron apparently similar to that of the Fitzwilliam statuette though its exact length and size are unknown. It is decorated with a design of spots and bordered with a spiraliform pattern made by two interlacing serpentine lines set within plain bands.

[1] *B.S.A.* IX, 369, Fig. 1; Evans, *Palace of Minos*, I, 261, 1.
[2] Maraghiannis, *Ant. Crétoises*, II, Pl. XXXIV, 6.
[3] Evans, *Palace of Minos*, I, Frontispiece, p. 501, Fig. 359.
[4] Cf. Murray, *Ancient Egypt*, 1926, pp. 36 ff.
[5] *B.S.A.* IX, 369, Fig. 1.

PLATE VII

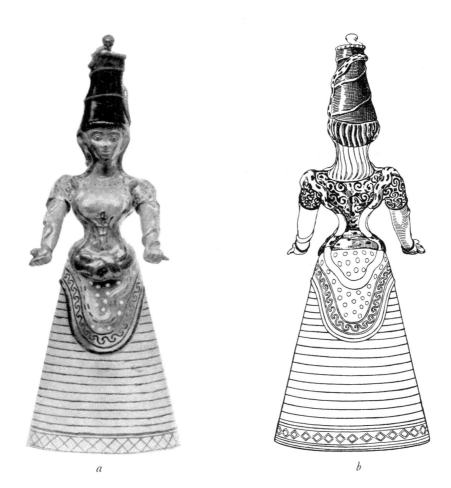

a *b*

FAIENCE FIGURINE OF SNAKE GODDESS FROM KNOSSOS. (Scale *c.* 1 : 3.)
a. Front. *b.* Back.

(4) A skirt missing except for a small portion on the thigh which shows a series of horizontal lines like those on the Fitzwilliam statuette.

(*b*) The Votary (Fig. 2) has also suffered considerably.[1] She is headless, but part of the headdress has been recognised. The left arm, two pieces from the hair and large portions of the apron and skirt are missing. She wears:

(1) As a headdress a circlet showing a series of raised medallions with a lioness or leopard seated in the centre of the front edge. The hair, which falls down the back in long waving tresses, reaches to the hips.

(2) A tight-fitting bodice of the same type and cut as that worn by the Snake Goddess. It leaves both breasts bare and is similarly laced in front and stands up stiffly so that it too must have had supports or "bones" of some kind. It shows at the back and on the sides and sleeves a pattern of waving lines of varying width. To judge by the fact that these lines are both wider and further apart at the top and narrower and closer together at the waist it would appear that this design was applied or worked after the material had been made up into the bodice. This strengthens the assumption that the design on the bodice of the Snake Goddess was worked after it was made up. Similarly the pattern on the M.M.II figurine from Phylakope must also have been made after the garment.[a]

[a] *Plate* VI, 2

(3) A girdle with a pattern of broad vertical lines between two horizontal lines which perhaps indicate a metal edging as suggested above.

(4) A double apron similar to that worn by the Fitzwilliam statuette but as the back is restored it is uncertain whether the back and front were of equal length. Its surface is covered with a net pattern and the upper part of each reticulation is crossed by two horizontal lines. The border enclosed between parallel bands is plain, but the edge seems to be padded or rolled.

(5) A skirt of the same type as that worn by the Fitzwilliam statuette. It is long and bell shaped and the foundation must have been cut with considerable flare. At the top just below the waist are three tucks or cords below which come six overlapping flounces. The upper edge of the upper flounce is hidden under the lowest cord and the top of each successive flounce below is set just under the hem of the one immediately above. The flounces were apparently pleated and each is divided regularly into a series of light and dark panels arranged alternately, so that a light panel in the penultimate flounce comes immediately above a dark panel in the bottom flounce.

(*c*) Another Votary[2] was found but only the lower part of the bodice, the waist, the apron and the parts of the skirt are preserved. She wears:

[1] *B.S.A.* IX, pp. 78 ff., Fig. 57; Evans, *Palace of Minos*, I, pp. 501 ff., Figs. 360–362.
[2] *Ibid.* I, pp. 505, 523, Fig. 382.

(1) A bodice of the same type, so far as can be seen, as those of the Snake Goddess and the Votary, and fastened in a similar manner.

(2) A girdle decorated with a spiraliform design set between two horizontal lines which may represent a metal edging.

(3) A double apron apparently of equal length at back and front. It is decorated with a pattern of spots like that of the Snake Goddess and trimmed with a border of the same spiraliform design as on the girdle, set between narrow bands of which the outer one is double.

(4) A long bell-shaped skirt like that of the Fitzwilliam statuette. It is ornamented with at least eighteen horizontal tucks,[1] and at the bottom has a border of a row of diamonds edged with fine lines and set between two broad lines. As the lower edge of the skirt must have been cut on the curve this pattern cannot be inwoven in the material (cf. Fig. 1), but would have been added after the skirt was made. As in the case of the Votary the hair seems to have hung down to the hips behind.

(d) Two Votive Dresses were found.[2] One is practically complete save for slight damage on its right side. It shows:

(1) A tight-fitting bodice with sleeves of elbow length and of the same type as that worn by the Fitzwilliam statuette. The opening in front is triangular and not cut so low; this may be due to the fact that it is shown in the flat and not on a figure. It is decorated with lines adapted to the shape of the garment and curving down from the shoulder to the waist. There are other lines running round the ends of the sleeves. These may all be seams or bindings treated decoratively and may not represent any ornamentation at all.

(2) A double rolled girdle round the waist.

(3) A skirt of the usual bell shape. Just below the waist this is decorated with a series of nine horizontal lines, probably tucks or cords. The lower tucks are broken into below by the top of a broad arched panel stretching right across the front of the skirt and outlined by two parallel waving lines, with a bold central motive, a clump of crocus or saffron in full bloom. Below this is a row of conventionalised crocus flowers, with a band along the very bottom of the skirt.

The other lacks practically all the bodice above the waist, but enough is left to prove its similarity to that of the first. Otherwise it shows:

(1) A double rolled girdle at the waist.

(2) A skirt of the usual bell shape. This has across its front an arched panel the

[1] The published restoration of this fragment (Evans, *Palace of Minos*, 1, 523, Fig. 382) seems slightly inaccurate in detail and gives no indication of its size.

[2] *B.S.A.* ix, pp. 81 ff., Fig. 58; Evans, *Palace of Minos*, 1, 506, Fig. 364.

PLATE VIII

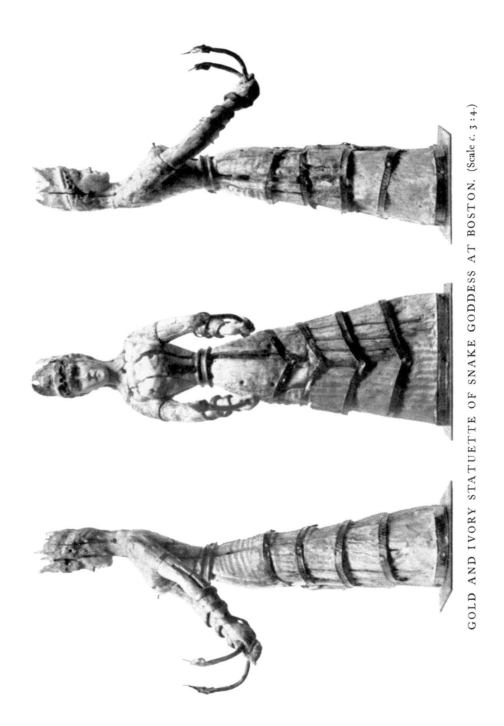

GOLD AND IVORY STATUETTE OF SNAKE GODDESS AT BOSTON. (Scale *c.* 3 : 4.)

top of which reaches to the waist. Inside the arch there are two cusps on either side which seem to anticipate Gothic ornament. This panel contains a mass of crocus in full bloom, but the clump is smaller than on the first, and below comes a border of three bands. In addition to these, votive girdles of faience with double rolls were also found. One of these shows on each roll a pattern of crocus flowers. The other has a design of rosettes and stars alternately between serpentine lines and this design goes over both rolls as they were one. A third double girdle, of which only a fragment was found, has a vandyke pattern.

The chryselephantine Snake Goddess at Boston,[1] which is undoubtedly Minoan in style and may even have come from Knossos itself,[2] is clad in a similar costume with certain differences in detail.[a] She wears: [a] *Plate* VIII

(1) On her head a circlet with a serrated top and a cylindrical piece in the centre. It suggests that worn by the faience Votary and resembles a crown or coronet. It sits high enough to show the hair beneath in front where loose curls were attached in gold. Each of the four serrations curves in a semicircle and has a hole near the top for affixing some ornament in gold, and the one in front has additional ornament in the form of a small boss. There was a gold band round the circlet at its base. The hair falls down between the shoulders in a mass of waving locks.

(2) A tight-fitting bodice of the type similar to that worn by the Fitzwilliam statuette. The sleeves reach only to the elbows, where they are edged with bands of gold, incised with a pattern of short stripes set horizontally in groups. There were other golden bands running down the front from the shoulders to the waist as trimming to the V-shaped opening. There is a small plate of gold triangular in form at the fastening of the bodice in front. This might be taken as confirmation of the suggestion that the fastening of bodices of this type was stiffened with metal, and recalls a golden ornament from the Third Shaft Grave at Mycenae.[3]

(3) A golden girdle round the waist. This is curved outwards at the edges so that they should not press into the figure. As Caskey suggests, it may be a golden girdle over a padded belt beneath it to prevent chafing.

(4) A long bell-shaped skirt. This at the top just below the waist shows horizontal lines carved in low relief which, like those on the Fitzwilliam statuette, may indicate tucks or cords. Below this come five successive pleated flounces which are so arranged as to dip into a point in the centre of the front as well as in the centre of the back. This, of course, does not apply to the lowest flounce which is horizontal. Each flounce has along its lower edge a gold binding which is in every case ornamented. That of

[1] Caskey, *A.J.A.* 1915, pp. 237 ff., Pls. x–xvi.
[2] Evans, *Palace of Minos,* I, 507.
[3] Schliemann, *Mycenae,* p. 199, Fig. 305.

the top flounce has a chevron pattern, the second repeats the sleeve edging, the third has a zigzag with dots, derived from the "notched plume" motive,[1] and the lowest a series of figure-of-eight shields.

Between the golden edge of the topmost flounce and the waist there are on each side of the central line of the skirt three small holes bored in a vertical line. It has been suggested that these were for affixing a golden apron on the model of that worn by the Knossos faience Snake Goddess. If so, the apron would have been single for there are no corresponding holes at the back. It would seem that the part of the skirt between the two rows of holes was covered, for the horizontal rows of tucks which run round the sides and back do not run across it. The holes may have held golden snakes, but when we consider that the golden bindings to the flounces of the skirt represent ornament, it seems more likely that there might have been a golden apron fastened to the front of the skirt as representing a textile apron decorated in some way or other.

Another important figure illustrating the same type of costume is the bronze Snake Goddess in Berlin.[2] In this, as in most Minoan bronze figures, the sharpness of the lines is blurred and details, especially of costume, are not

[a]*Plate* IX clear.[a] The figure seems to be wearing a tight-fitting bodice of the same type[3] as that of the Fitzwilliam statuette, and also a bell-shaped skirt with four flounces dipping to a point in front and horizontal behind. Round her waist is a wide rolled sash, one end of which hangs down the skirt centre in front, slightly to one side of the dipping point of the top flounce. This resembles

[b]*Plate* VI,1 the sash of the Petsophas figurines[b] and, as there, may here also conceal a placket, which would be essential for the wearer to put on the skirt.

Another example of this same skirt is to be seen on a fresco fragment from

[c]*Plate* X Agia Triada[c] showing a seated woman.[4] She wears:

(1) A close-fitting bodice of white material decorated with small dots. It meets with a sharp V in front and is edged with a band of blue and red.

(2) A girdle of blue stuff bordered with a plain red band on either side, similar to the edging of the bodice.

(3) A bell-shaped skirt which in the drawing strongly resembles trousers, but as Tsountas and Manatt say,[5] "we must take the bifurcation as the artist's effort to

[1] Evans, *Palace of Minos*, I, 550.

[2] With this may be compared the two small bronzes from Agia Triada, Maraghiannis, *Ant. Crétoises*, I, Pl. xxvi, 2, 3; Bossert, *Altkreta*², Figs. 136 *b*, 137.

[3] Caskey (*A.J.A.* 1915, p. 248) thinks it is naked above the waist, but see Bossert, *Zeit. bild. Kunst*, xxxii, 66. [4] *Mon. Ant.* xiii, pp. 59 ff., Pl. x.

[5] *Mycenaean Age*, p. 171, 1; cf. Rodenwaldt, *Tiryns*, ii, 77, 4.

PLATE IX

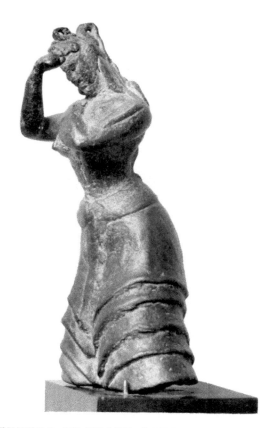

BRONZE STATUETTE OF SNAKE GODDESS AT BERLIN. (Scale *c.* 1 : 2.)

PLATE X

SEATED FIGURE IN FRESCO FROM AGIA TRIADA. (Scale *c.* 1 : 10.)

express the limbs rather than as a voucher for the prehistoric origin of the divided skirt". The upper part reaching halfway to the knees is a foundation of blue stuff with a pattern of contiguous crosses in blue and white, the latter having the median lines marked in red. At the point where the uppermost flounce is attached it is bordered with a white band decorated with a succession of red scrolls, separate but giving an effect of continuity, and bordered with a plain red band on either side. Then come two flounces reaching to the knee, each patterned with vertical blocks of colour, red, blue, white, and brown, repeating in the same order. The lower part of the skirt, which ends at the bottom of the calf (but it must be remembered that the wearer is seated or half seated and so the skirt would be slightly drawn up), repeats the patterns and arrangement of the upper half. All the flounces appear to be set on so as to dip to a point in the centres of both front and back. The cross design of the foundation is cut on the bias. This shows that the design is inwoven and not embroidered or applied.

There are two important series of fresco fragments from the Mainland, remains of friezes of women, from Thebes and Tiryns, which are so numerous that though no one figure is preserved whole there is enough evidence for attempting a reconstruction of the general type. The Theban[1] are the earlier and date from Late Helladic I–II. As restored the figures wear:

(1) A tight-fitting bodice cut low on a wide curve in front so as to expose the whole bosom, fastened tightly at the waist and with rather loose sleeves reaching to the elbow. The bodice and sleeves are of one colour and both are trimmed with a border of short stripes, thick and thin, and of varying colour.

(2) A double belt with a vandyke pattern which may represent either an inwoven design or embossed gold plates applied to a textile foundation.

(3) A bell-shaped skirt of the usual type decorated with pleated flounces. The upper part of the skirt shows the foundation ornamented with small dots or a speckled pattern. Then come three flounces set so as to dip to a point in the centre of the front. They vary in colour and are decorated with parallel stripes similar to that of the trimming on the bodice. Then comes another wide belt of the speckled pattern on the foundation and below that three more flounces similar to those above.

The Tirynthian[2] women[a] date from Late Helladic III and though so much later in date show that the same type of dress still remained in fashion. They wear: ᵃ*Plate* XIII, 1

(1) A close-fitting bodice of red with short sleeves of elbow length. It is trimmed with a border showing a pattern of heart-shaped or ivy leaf devices set so that the

[1] Ἀρχ. Δελτίον, III, 339, Fig. 193.
[2] Rodenwaldt, *Tiryns*, II, pp. 69 ff., Pl. VIII.

point of one fits into the base of the next and so on, thus forming a continuous band. On each side is an edging of one row of blue and one of yellow short parallel stripes.

(2) A waist belt or girdle ornamented in exactly the same way as the trimming on the bodice.

(3) A bell-shaped skirt of the usual type with pleated flounces dipping to a point in the centre front. At the top just below the waist is a wide belt with a pattern of overlapping scales. On each scale is a tongue-shaped leaf pointing upwards. Next comes a belt of three flounces of which the upper and middle are decorated with short parallel vertical stripes of white, red, blue, and yellow. The middle flounce has a curved tongue pattern in blue on a white ground which resembles the "notched plume".[1] Next comes another belt of overlapping scales in blue followed by three more flounces similarly ornamented. Below this comes a belt of scale pattern in yellow followed by three flounces like those above. Another belt of scale pattern in blue follows and lastly a fourth and final series of three flounces.

These are the best representations of costume which in any way approach that of the Fitzwilliam statuette. The miniature and procession frescoes from Knossos illustrate many of the same type, but are not yet published, while other frescoes published, such as the Ladies in Blue from Knossos[2] or the woman in relief from Pseira,[3] are too fragmentary to provide any evidence for details. Women wearing costumes both similar and dissimilar occur on signets of gold and stone and also on seal impressions in clay,[4] but as a rule these are on too small a scale or too rough to be a safe guide.[5] In some cases it is hard to see, especially on seal impressions, whether the person represented is a woman or a man. The dresses on the Agia Triada sarcophagus[6] and on the gold ring from Tiryns[7] are different and as they probably represent vestments used for a religious or ritual purpose have no concern here. The best examples of costumes on a small scale are perhaps to be seen on two gold rings from

[1] Evans, *Palace of Minos*, i, pp. 548 ff.

[2] *Ibid.* i, 545, Fig. 397.

[3] Maraghiannis, *Ant. Crétoises*, ii, Pl. xviii.

[4] Rodenwaldt (*Tiryns*, ii, pp. 76 ff.) quotes the more important parallels. The ivory mirror handles from Mycenae (Tsountas-Manatt, *Mycenaean Age*, pp. 186 ff., Figs. 82–84) can also be compared.

[5] *E.g. B.S.A.* xii, 241, Figs. 1–5; cf. Karo, *Religion d. ägäischen Kreises*, Figs. 66 ff.

[6] Maraghiannis, *Ant. Crétoises*, ii, Pls. xliv, xlv.

[7] Karo, *Religion d. ägäischen Kreises*, Fig. 87.

PLATE XI

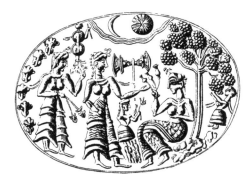

1. GOLD RING FROM ACROPOLIS TREASURE, MYCENAE. (Scale 2 : 1.)

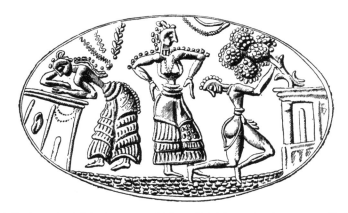

2. GOLD RING FROM CHAMBER TOMB, MYCENAE. (Scale 3 : 1.)

Mycenae[1]. On one (Plate XI, 1) the goddess seated under the tree on the right wears a flared skirt with two sets of three dipping flounces and above each set is a broad belt of scale pattern. The scale pattern recalls the Tirynthian woman[a] while the arrangement of the flounces resembles that of the [a] *Plate* XIII, 1 Theban and Agia Triada[b] women. A similar skirt is worn by the first [b] *Plate* X votary and the second standing on the extreme left has the same type of skirt but without the scale pattern. On the other ring (Plate XI, 2) the two women wear similar skirts, both with traces of a scale or rosette pattern. None of the figures on the two rings (except perhaps the central woman on Plate XI, 2) has any definite indication of a bodice, but in view of larger and complete figures like the Boston Snake Goddess there can be little doubt that all such female figures which appear to be naked above the waist were not so in reality, as the small scale prevents the indication of sufficient detail. The bodice, too, fits the figure closely and is cut very low in front. Occasionally, on small objects of gold, if the scale is not too small, the bodice is shown as on the ornamented pin from the Third Shaft Grave at Mycenae[2] already mentioned. Sometimes even larger figures, such as the female statuette in lead from Kampos[3], are in so poor a condition that no details of the costume can be discerned.

[1] Schliemann, *Mycenae*, p. 354, Fig. 530; *J.H.S.* 1901, p. 177, Fig. 53; Karo, *op. cit.* Figs. 72, 75.

[2] Schliemann, *Mycenae*, p. 193, Fig. 292; Karo, *op. cit.* Fig. 53.

[3] Stais, *Coll. Myc.*[2] p. 159.

IV

TEXTILE MATERIALS AND METHODS

IV. TEXTILE MATERIALS AND METHODS

THE costumes of the Snake Goddess and some of the representations mentioned above are often said to be richly embroidered[1] and as the words "rich embroidery" nearly always in modern times connote the use of silk, we must consider what textile materials were available to the inhabitants of Crete and the Greek Mainland in the Bronze Age. Silk was not known in the Aegean basin till late in the classical period and so may at once be excluded. Cotton, too, was not introduced into Greece till historic times and thus of the four textile materials usual to-day linen and wool, which are both freely mentioned by Homer,[2] are the only two that can have been used for making and ornamenting the dresses of Minoan women. Sheep rearing has been from time immemorial one of the principal trades of the Greek Mainland and islands and so there is no reason to doubt that people so advanced in other crafts as the Cretans, were not well acquainted with the spinning and weaving of wool, although the oldest evidence is that of Homer.[3]

With linen it is different and we have no means of judging how soon flax was cultivated. Remains of linen, however, and even of unspun flax have been found in the Swiss lake dwellings and in Italian terramare[4]. If peoples like these in a more primitive state of society spun flax and wove linen there is every reason to believe that it was also used in Crete.[5] At Mycenae Schliemann found some fragments of linen in the Fourth Shaft Grave[6] and small fragments of linen have been found in tombs of the early Iron Age,[7] and since it is hard to believe that all the linen used was imported into Greece at so early a period flax presumably must have been cultivated. When wheat, barley, lentils, peas

[1] Evans, *B.S.A.* IX, 70, and *Palace of Minos*, I, 500; Mackenzie, *B.S.A.* XII, 243; cf. Wace, *apud Cambridge Ancient History*, II, 436.

[2] Studniczka, *Altgriechische Tracht*, pp. 45 ff.; Seymour, *Life in the Homeric Age*, pp. 155, 159.

[3] Studniczka, *op. cit., loc. cit.*; Seymour, *op. cit.*, p. 135.

[4] Studniczka, *op. cit.*, p. 46; Peet, *Stone and Bronze Ages in Italy*, p. 362.

[5] Spindle whorls are commonly found both in Crete and on the Mainland.

[6] Schliemann, *Mycenae*, p. 283.

[7] Wace-Thompson, *Prehistoric Thessaly*, p. 213.

and probably figs were cultivated in Thessaly[1] it is hard to believe that the more progressive folk of southern Greece were unacquainted with so common a natural product as flax.[2]

In Egypt linen has been found in tombs from early dynastic times onwards[3] and as civilisation progressed considerable skill in weaving fine linen was attained at a comparatively early period. Decorated linen is not rare. Of the XIIth Dynasty there is a good example of pleated linen from Dashur and representations of striped linen in the tomb of Senebtesi.[4] Of XVIIIth Dynasty date there are examples of striped linen from Thebes[5] and some fine fragments of decorated linen from the tomb of Thothmes IV.[6] One of these is part of a robe with a tapestry woven decoration of lilies, and hieroglyphs of the name of Amenhotep II. A more interesting piece is thus described: " Portion of a garment coarsely woven in linen threads (warp 25 threads, woof 30 threads to the millimetre) and divided vertically into fourteen narrow bands by thick double threads of linen dyed pink and woven into the material. The four bands on the right-hand side are plain, the remaining ten are ornamented with rosettes wrought in needlework, each rosette being composed of a pale green centre with six pale pink petals, except in the thirteenth row, where pink rosettes alternate with green petalled rosettes with pink centres". Unfortunately the material of the " wrought needlework " is not mentioned, but presumably it is linen. The tomb of Tutankhamen also contained many examples of decorated linen robes. These are not yet published but the provisional account says:[7] " Many of them are decorated with patterns in coloured linen threads. Some of these are examples of tapestry weaving similar to the fragments found in the tomb of Thothmes IV, but there were also

[1] Tsountas, Προϊστορικαὶ Ἀκροπόλεις, p. 359; Wace-Thompson, *op. cit.*, p. 262.

[2] Other vegetable fibres may have been used (*Cambridge Companion to Greek Studies*, p. 67), but are hardly likely to have been general when the long use of flax in Egypt is considered.

[3] *Cambridge Ancient History*, I, 240; II, 422.

[4] Winlock-Mace, *Tomb of Senebtesi*, p. 42, Fig. 25.

[5] Carnarvon-Carter, *Five Years' Exploration at Thebes*, p. 25, "linen marked in light and dark blue and red striated with dark blue running the whole length woven in".

[6] Carter-Newberry, *Tomb of Thoutmosis IV* (*Cat. Gén. d. Ant. Eg. du Musée du Caire*), Nos. 46,526–46,529, Pls. I, xxviii.

[7] Carter-Mace, *Tomb of Tutankhamen*, I, p. 235.

undoubted cases of applied needlework." Among the tapestry woven pieces was a glove.[1] An XVIIIth Dynasty linen in the Victoria and Albert Museum[2] and the girdle of Rameses III[3] (Plate XII) show that patterned stuffs were woven, if only on a small scale, well before 1100 B.C. It was also possible to inscribe linen in ink and there are examples of painted linen from Deir el Bahri in the Victoria and Albert Museum.[4] There is also good evidence for decorating both the garments and the hair with bead work or with rosettes of gold or gilt copper.[5]

In view of the well-known intercourse between the Nile Valley and Crete and Mycenae this enables us to make suggestions as to the probable character of the decoration on the Minoan and Mycenaean costumes described above. In every case as regards both the patterns and the costumes themselves we must remember that we have not the actual costumes, but only the artist's representations of them, and artists' ideas and pictures of costumes are not always accurate, witness the annual criticisms of *The Tailor and Cutter* on the Royal Academy Exhibition. In deciding, too, whether a pattern is inwoven or applied in embroidery or some other way the cut and make of the garments must be taken into account. For instance, Lady Evans' suggestion, which Rodenwaldt favours,[6] that the pattern on the bottom of the skirt used as a model for restoring that of the Knossian Snake Goddess is inwoven, is impracticable as explained above because the bottom of a flared skirt is not at right angles to its axis but cut with a curve, as shown here in Fig. 1. Coloured linen threads must be assumed on the Egyptian evidence as the most likely material for embroidery, but woollen embroidery not much dissimilar to English seventeenth-century crewel work may have been used in Greek lands. Wool was as plentiful in Greece as it was rare in Egypt which was *par excellence* the land of flax.

[1] *Op. cit.*, Pl. LXXIX b. [2] T. 251–1921; Burlington Club, *Cat. Eg. Art*, 1922, p. 54.
[3] Lee, *Liverpool Annals*, v, pp. 84 ff., Pl. XI; Van Gennep-Jequier, *Tissage aux Cartons*, pp. 93 ff.; Ling Roth, *Ancient Eg. and Greek Looms*, p. 24; Van Reesema, *Early History of Textile Technics*, pp. 47 ff. [4] Nos. 468–1906, 728–1907.
[5] *E.g.* beadwork girdle from the Tomb of Senebtesi, Winlock-Mace, *Tomb of S.*, Pl. XXXI; gold rosettes, Tomb of Senebtesi, Winlock-Mace, *op. cit.*, Pl. XXI, p. 59; gold and gilt copper rosettes, T. M. Davis, *Harmhabi and Touatânkhamanou*, Pl. LXXXIX, pp. 133 ff., Fig. 13; *id. Tomb of Queen Tîyi*, p. 40, Nos. 54–56, Pl. V, 8; Carter-Mace, *Tomb of Tutankhamen*, I, Pl. LXXVIII. [6] *Tiryns*, II, 77.

Tapestry woven ornament in linen or wool was also very probably in use as in Egypt. It is a simple method of weaving ornament and was extensively employed in Graeco-Roman Egypt.[1] Homer represents Helen as weaving a fabric decorated with the wars of Greeks and Trojans;[2] this would presumably have been tapestry, as more elaborate methods of weaving would have been then unknown.

The patterns on the Middle Minoan figurines from Phylakopē and Petsophas in both cases follow the lines of the garments and must have been applied[a]. It may have been painted, embroidered, or perhaps rendered by sewing pieces of different coloured stuff to the foundation, rather in the style of patch or appliqué work. As shown above,[3] the pattern on the skirt of the faience Snake Goddess from Knossos[b] cannot be inwoven and we must consider the horizontal lines as tucks or cording on the model of the pleated linen from Dashur.[4] Some support, such as would be given by tucks of this kind, is needed to make the skirt stand out.[5] The decorated band at the bottom might be embroidery or bead work or perhaps even a woven belt like the girdle of Rameses III[6] applied to the linen foundation. The decoration of the bodice may possibly be inwoven but as the design is curvilinear and not angular in outline it suggests embroidery or painting. Also, though it is just possible that the garment was cut out of patterned material, the way in which the pattern follows the lines of the bodice and the latter fits the figure suggests that the decoration was applied after the bodice was cut out. The apron with its pattern of spots may easily have been inwoven, probably by the tapestry process.[7] The ornament along its edge might be a woven braid or a band of bead work though it might be difficult to get such work to fit the curved outline and still preserve the design; so it would be preferable to consider it as a piece of stuff put on as binding round the edge and then embroidered.

[a] *Plate* VI, 1, 2

[b] *Plate* VII

[1] See Kendrick, *Cat. of Textiles from Burying Grounds in Egypt* (Victoria and Albert Museum).

[2] *Iliad*, III, 125. [3] See pp. 10(7), 29.

[4] Winlock-Mace, *Tomb of Senebtesi*, p. 42, Fig. 25.

[5] Dawkins (*B.S.A.* x, 218) suggests the use of a crinoline or farthingale, but there is no evidence for this. [6] Lee, *Liverpool Annals*, v, Pl. xi.

[7] Tapestry woven aprons are a common feature of modern peasant costumes in Jugoslavia.

PLATE XII

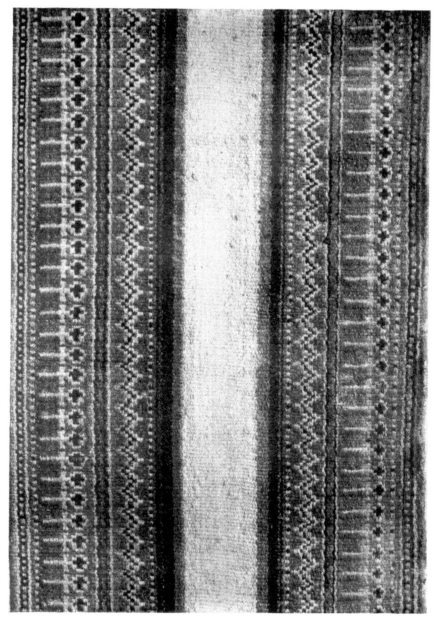

THE GIRDLE OF RAMESES III AT LIVERPOOL. (Scale 1 : 1.)

On the skirt of the Votary (Fig. 2) the horizontal lines at the top represent tucks or cords as before and the designs of solid colour on the flounces are probably inwoven, the flounces being made from a linen simply woven with stripes of varying width and colour. The diaper pattern of the apron again suggests weaving as before, probably tapestry weaving, and the border might be some kind of braid. The decoration of the bodice, however, must have been applied after it was made and so cannot be inwoven, but should be some kind of embroidery or appliqué work.

The larger votive dress has horizontal tucks at the top of the skirt and below an elaborate panel and border with crocus designs, which, as they fit the shape of the skirt, must have been worked after it was made. They would most probably be painted or embroidered like the rosettes on the linen from the tomb of Thothmes IV. The pattern on the bodice again fits the shape and so would probably consist of bands of different stuff applied to the foundation. The decoration of the smaller votive dress would have been carried out on similar lines. It is hard to suggest with any degree of confidence how the patterns on the two votive girdles were made though the girdle of Rameses III[a] and the bead work girdle from the tomb of Senebtesi[1] supply possible parallels. One girdle with the crocus design may have been decorated before it was made up, but on the other some at least of the pattern seems to have been worked afterwards. Bead work, embroidery, weaving, or applied metal work are all equally possible. *[a] Plate XII

The bodice of the woman in the Agia Triada fresco[b] has a pattern of small dots[2] and as the piece preserved is so small it is impossible to suggest how it may have been worked. The girdle and border of the bodice have the same pattern and so may have both been made from a woven band not unlike the girdle of Rameses III. The skirt seems to have been made thus. The upper part, to judge by the way in which the decoration[3] is cut, by the shape appears to have been made of a material with an inwoven pattern. Below this come two pleated flounces made, as in the skirt of the faience Votary (Fig. 2), of linen woven with simple bands of different colours. The upper edge of the top flounce would be masked with a woven braid or band of bead *[b] Plate X

[1] Winlock-Mace, *Tomb of Senebtesi*, Pl. xxxi.
[2] Cf. Fyfe, *J.R.I.B.A.* 1902–3, p. 117, Figs. 34, 36, 37.
[3] For the pattern cf. Fyfe, *op. cit.*, p. 117, Fig. 40, p. 128, Fig. 68.

work or, if the shape would prevent this being applied without interrupting the design, with a piece of linen embroidered to suit the shape. The lower part of the skirt repeats the upper.

a *Plate* VIII

The chryselephantine Snake Goddess at Boston[a] is monochrome except for the gold bands and therefore gives no hints as to the textile character or design of the costume. The gold bindings on the flounces of the skirt and on the sleeves and fastening on the bodice and the golden girdle may be miniature representations of actual golden ornamentation on the dresses. In the Third Shaft Grave at Mycenae, which contained the bodies of three women, Schliemann found some V-shaped pieces of gold with holes for attachment[1] and it is just possible that these are full-size examples of the V-shaped fastening of the bodice or may have been metal "bones" for it. The gold bindings on the sleeves and the flounces will be further discussed below.

The women of the Theban frescoes have their bodices made of plain undecorated stuff, but the sleeves and the opening round the bosom are edged with a striped pattern. This may be a braid woven with simple stripes of various colours or else an applied band made up of pieces of differently coloured stuffs. The double belt with the vandyke pattern may well be a woven band like the girdle of Rameses III or equally well a linen girdle decorated with embossed strips of gold. The flounces of the skirt, like those of the woman in the Agia Triada fresco, are probably made from a stuff woven with plain stripes of different colours. The spotted material which serves as a foundation for the flounces may have had its spotted pattern woven into it, but it is quite likely that the spots represent small sequins like those on the robe of Tutankhamen.[2]

The women of the Tirynthian frieze[b] wear bodices made of a plain red material. The sleeves, the front, and the waist are edged with a braid of blue and yellow stripes which may well be woven. The disturbance of the pattern at the curves and at the corners of the sleeves indicates clearly that this pattern was woven before the braid was applied and not afterwards. Down the middle of the braid runs a continuous line of leaf or heart-shaped ornaments. These are white and may well have been golden or silver ornaments sewn on the braid as extra decoration.[3] Strips of embossed gold with a similar pattern were found by Tsountas in the grave pit in the dromos of the Tomb of

[1] Schliemann, *Mycenae*, p. 199, Fig. 305.
[2] Carter-Mace, *Tomb of Tutankhamen*, I, Pl. LXXVIII.
[3] Cf. Rodenwaldt, *Tiryns*, II, 80, 4.

PLATE XIII

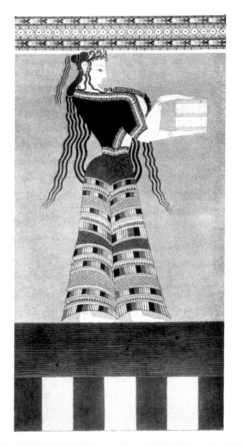

1. RECONSTRUCTION OF FIGURE IN FRESCO
FROM TIRYNS. (Scale 1 : 20.)

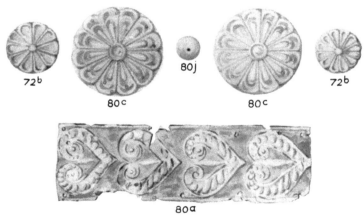

2. GOLD ROSETTES (72b, 80c) AND GOLD STRIP (80a)
FROM TOMB 515, MYCENAE. (Scale 3 : 4.)

Clytemnestra[1] and as these have holes pierced regularly along the edges may have been attached to the edges of clothes in much the way in which the golden edging is attached to the sleeves and flounces of the Boston chryselephantine statuette. Similar strips of embossed gold with holes pierced along the edges were found in Tomb 515 at Mycenae together with a number of gold rosettes also pierced[a]. Such strips are well adapted for adorning the edges of a bodice, a girdle, or the flounces of a skirt as suggested, and the golden binding on the flounces of the Boston Snake Goddess may quite well represent the material of the actual ornamentation. The skirts of the Tirynthian women are decorated with four wide bands of scale pattern alternately yellow and blue and between them with triple flounces. The upper and lower members of each group of flounces have a striped pattern and so were probably, as in other cases, made out of a material simply woven with stripes of different colours. The central member has a tongue or "notched plume" design, which may have been woven but equally well have been of bead work or embroidery or applied metal. The scales on the wide bands between the flounces overlap one another and certainly do not suggest inwoven designs. It has long been suggested[2] that the gold rosettes found in the Third Shaft Grave,[3] which contained the bodies of three women, and in other tombs at Mycenae and elsewhere were intended for the adornment of costumes. In Tomb 515 at Mycenae a large number of such rosettes[b] were found on the floor of the same grave pit which contained the strips of embossed gold just mentioned. The rosettes lay close[4] together overlapping one another and several of them were folded as though caught in the folds of a garment. Each rosette was pierced with holes round the edge, except in nearly every case at one point the line of holes leaves the edge and follows a chord across the rosette to the edge again. This distinctly suggests the use of rosettes laid over one another like scales and sewn down on to a linen backing to decorate skirts like those worn by the Tirynthian women.[5] Such a use of the rosettes is well paralleled by the

[a] *Plate* XIII, 2

[b] *Plate* XIII, 2

[1] *B.S.A.* xxv, 365, Fig. 79 *d*.

[2] *E.g.* Ridgeway, *Early Age of Greece*, p. 8; Schuchhardt, *Schliemann's Excavations*, p. 202.

[3] Schliemann, *Mycenae*, pp. 165 ff., Figs. 239–252.

[4] A workman who excavated here described the gold rosettes as lying like sardines.

[5] Dr Stais has suggested that the rosettes from the Third Shaft Grave decorated wooden coffins ('Εφ. 'Αρχ. 1907, pp. 31 ff.; *Coll. Myc.*², p. 6; cf. *Jahrbuch*, 1912, pp. 208 ff.), for which there is no other evidence. Rosettes were also found under the

Egyptian evidence already quoted and the use of two colours for the rosettes on these skirts possibly means that the yellow scales were gold and the blue silver.[1]

bodies (Schliemann, *Mycenae*, p. 165) and it is hardly to be supposed that the rosettes were on bottoms of coffins. Although many pieces of wood were found in the Fifth Shaft Grave (Schliemann, *Mycenae*, p. 332), Schliemann found no trace of a coffin in this grave or in any of the others. The Sixth Grave clearly had no wooden coffins, because the remains of the skeleton of the first interment were piled together in a corner. The rosettes too are confined to the Fifth which had only seventeen, and to the Third Grave where there was an immense number. As the latter grave contained three women, it is extremely probable that such rosettes adorned women's skirts as suggested.

[1] Cf. *B.S.A.* VII, 56.

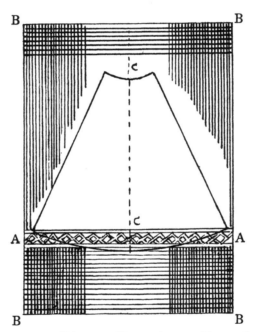

Fig. 1. Diagram illustrating problem of cutting bell skirt from stuff with woven pattern (A—A).

C—C. Central line of skirt, parallel to selvedge (B—B).

V
SUMMARY

V. SUMMARY

FROM this review of the other representations of women in Minoan and Mycenaean art which are sufficiently detailed and from the analysis of their dress and the materials that could have been employed we come back to a further consideration of these points as regards the Fitzwilliam statuette. As noted there are no traces of colour now visible, but these may have vanished and the patterns of the garments are rendered by carving in low relief. It is always possible, as for instance in the flounces of the skirt, that the sinkings may be intended to represent either actual pleating or bands of different colours, as in the Tirynthian women[a]. Still in the absence of colour it is more reasonable to take the incisions as representing actual pleats. In any case since both the bodice and the skirt are of fine material shaped to the figure and cut on dressmaking principles, they were probably of linen. Here there is a distinct difference from Egyptian dress of the same period which was long and loose and except for very highly placed persons plain white.[1] Such a costume required practically no tailoring,[2] while the Minoan women's dress demanded skilful cutters and good fitters. We can thus conclude that the bodice of the Fitzwilliam statuette was of linen and of one uniform colour, if we can judge by the Theban and Tirynthian women who are later in date. It might have been decorated with embroidery like the bodice of the faience Snake Goddess from Knossos[b]. At the ends of the sleeves and at the waist there may have been a binding of braid or perhaps of a strip of embossed gold laid on a band of linen and sewn on. The girdle may have been of patterned linen like that of Rameses III[c] perhaps with added ornaments of gold like that of the princess at Dendra. In an elaborate costume, however, the girdle was probably of gold, perhaps on a linen backing, on the model of the golden belt of the Boston Snake Goddess[3] or perhaps of the sword belts from the Shaft Graves of Mycenae.[4] The headdress was perhaps of some thick woollen material or may even have been of leather. In the latter case it would recall the Homeric helmets of leather protected with boar's tusks.[5]

[a] *Plate* XIII, 1

[b] *Plate* VII

[c] *Plate* XII

[1] *Cambridge Ancient History*, II, pp. 99, 420 ff.
[2] The same holds true of classical Greek dress.
[3] See above p. 19; Caskey, *A.J.A.* 1915, 241.
[4] Schliemann, *Mycenae*, pp. 244, 299, Figs. 354, 455.
[5] Reichel, *Homerische Waffen*[2], pp. 101 ff.

The beading round the divisions of the headdress would most likely have been a row of beads of faience, paste, or gold sewn on. The apron, as we have seen, was probably tapestry woven of wool and this process of weaving would have enabled the pattern to be woven into the material, an idea not inconsistent with the patterned aprons represented on similar figures. The binding of the apron edge would have been ornamented either with embroidery or with embossed gold strips and then fitted round the edge. The skirt and its flounces would be of linen, the latter probably being made of material woven with coloured stripes. Any woollen textile at that early date would have been of too coarse a texture to enable the garment to be so well cut and fitted especially over the hips. Still the bottom of the skirt may have been lined with a broad band of thick flannel to stiffen it and make it stand out, as is done in some of the modern costumes of the Greek islands, for instance, in the overskirts of Astypalaea.

We have treated the skirt of the Fitzwilliam figure and the other representations of the same type of costume as bell-shaped or flared skirt ornamented with pleated flounces sewn on so as to be horizontal in front and to dip to a point in the centre of the back.

Dr Mackenzie[1] has suggested that such a dress does not represent a flounced skirt, but a series of multiple skirts. This theory would mean in the present [a]*Plate* X case that the figure wears at least five skirts and that the Agia Triada woman[a] [b]*Plate* XIII, 1 wears six and the women of the Tirynthian frieze[b] wear sixteen skirts. Each of these skirts would presumably be fastened at the waist and a mere brief reflection as to the waist thickness caused by a layer of five skirts or more shows that the trim waists of the Knossos and Boston Snake Goddesses or the women on the frescoes mentioned would have been impossible. Both Caskey[2] and Rodenwaldt[3] have pointed out that Mackenzie's theory as to the evolution of the Minoan female costume, which is a restatement of Tsountas' suggestion[4] that the dress of men and women was once the same and consisted only of a loin cloth, is purely speculative and has no evidence to support it.[5]

[1] *B.S.A.* XII, pp. 239 ff. [2] *A.J.A.* 1915, 243, 1. [3] *Tiryns*, II, 79.
[4] Tsountas-Manatt, *Mycenaean Age*, pp. 172, 175.
[5] His conjecture is based on the idea that the apron of the Knossian Snake Goddess represents the primeval loin cloth. The apron, however, does not appear on all the costumes in the frescoes, *e.g.* Agia Triada, Thebes, Tiryns, and is absent from the

It is impossible, however, to believe that costume did not develop as civilisation advanced or change according to the dictates of fashion. We have too little evidence as yet for us to advance any theory as to its evolution; we can only collect the examples. In any case the Middle Minoan costumes of the Khamaizi and Petsophas figures[a] seem to be one-piece frocks with an opening down the front covered by a sash. When a close-fitting bodice and skirt developed from this it was naturally easiest to make a two-piece costume for convenience of dressing or undressing. The Berlin bronze[b] seems to represent the next stage, for though it has the later type skirt, there seems to be a placket in front hidden by the sash as in the Petsophas figurines. Further, in the skirts of the type we have been discussing Sir Arthur Evans[1] has pointed out that the flounces are at first horizontal and later so placed as to dip down into points in the centre of the front and back. He also adds that a chemise was worn in the Late Minoan period, but the only evidence for this so far published is an inadequately illustrated fresco from Knossos.[2] Pending full publication of the Knossian frescoes judgment must be suspended upon this point, but a chemise to be diaphanous must have been of a very open-meshed linen.

[a] Plate VI, 1

[b] Plate IX

Khamaizi and Petsophas figurines which are Middle Minoan I and earlier in date. Further, he follows Myres' suggestion (*B.S.A.* IX, 386) that the squatting clay figurines of the Cretan neolithic age wear the bell skirt and apron. A glance at the illustrations of these figurines (Evans, *Palace of Minos*, I, 46, Fig. 12) is enough to show that they are so crude and shapeless that no theory as to the evolution of dress ought to be based on them. His suggestion that some of the figures wear divided skirts or multiple divided skirts was answered in anticipation by Tsountas and Manatt's remark (*Myc. Age*, p. 171, 1; cf. Rodenwaldt, *Tiryns*, II, 77, 4) quoted above. A bell skirt worn without any petticoats underneath will naturally flop between the knees when the wearer is sitting and if drawn by a primitive artist of limited technique will at first sight give the impression of a divided skirt. His reference to the loin cloth worn by the women in the Cowboy fresco from Knossos is of no weight because it is what we would term a sports costume. One would hardly expect a circus performer in any age to do her tricks in a long bell skirt which would hobble her movements and make failure in bull vaulting certain. Similarly ballet dancers are noted for the brevity of their skirts.

[1] *Palace of Minos*, I, 503. [2] *B.S.A.* VIII, 58, Fig. 28.

VI

DATE, SUBJECT, AND STYLE

VI. DATE, SUBJECT, AND STYLE

THESE details of the costume are important as assisting materially to date the Fitzwilliam statuette. The flounces of the faience votaries from Knossos, which date from the later part of Middle Minoan III, are set on horizontally. The flounces of the Boston goddess dip to a point in the centres of the front and of the back. The flounces of the Theban and Tirynthian women and those so far as can be seen on engraved rings from Mycenae dip to points both in front and behind. This would indicate that the Fitzwilliam statuette shows a transitional fashion between the Knossian and Boston Snake Goddesses and that the Agia Triada, Theban, and Tirynthian frescoes, which show more developed flounces, are later. The Boston statuette is of the same style as the ivory acrobats from Knossos and Sir Arthur Evans thinks they all formed part of the same deposit.[1] Thus the Boston Goddess is to be assigned to Late Minoan I and the Fitzwilliam statuette may accordingly be considered slightly anterior in date, but of the same age, as it is later than the Knossian Snake Goddess which is M.M.III. The bronze Snake Goddess at Berlin[a] [a] *Plate* IX from its likeness in technique to the bronze from Tylissos,[2] which is Late Minoan I, is most probably contemporary. So the Fitzwilliam statuette may be dated to Late Minoan I, that is to say the sixteenth century B.C. As information about the place and manner of the discovery of this statuette is unobtainable, valuable assistance for deciding its subject is lacking. The whole subject of the different classes of figurines and statuettes in various materials and of a religious nature is being thoroughly discussed by Professor Nilsson in his forthcoming book.[3] He separates them into three groups: votive figurines from sanctuaries, such as those from Petsophas, or Gioukhtas[4] or the Psykhro cave;[5] cult statuettes from shrines; and figurines from tombs. To the second group belong the faience figures of the Temple Repositories and the terracottas of the Shrine of Double Axes from Knossos,[6] the bell-shaped terracottas from Agia Triada[7] and Gournia.[8] Lastly there are stray finds the original purpose of which is more or less uncertain. Our statuette

[1] *Palace of Minos*, I, 507. [2] Khatzidakis, Ἐφ. Ἀρχ. 1912, 223, Pl. 17.

[3] *Minoan-Mycenæan Religion*, chap. IX, especially pp. 251 ff.

[4] Evans, *Palace of Minos*, I, 158.

[5] *B.S.A.* VI, pp. 105 ff. [6] *Ibid.* VIII, 99, Fig. 56.

[7] Maraghiannis, *Ant. Crétoises*, I, Pl. XXVI, 4–6. [8] *Ibid.* I, Pl. XXXVI.

falls into this last group. Its resemblance, however, to the type of the Knossian faience figurines, to the Boston Snake Goddess, which Sir Arthur Evans believes belonged to a group of ivories from Knossos, suggests that it belonged to a cult group. This is supported by the evidence of the hole in the base which hints that it formed part of a group like the ring dancers from Palaikastro. If so it may well have been one of a series of cult figures representing a goddess and her votaries and so have formed part of the equipment of a shrine, but there is nothing to show whether it is a goddess or a votary. It might be urged in favour of the former that she clasps her breasts with her hands and might thus be a mother goddess of the well-known oriental type. Professor Nilsson,[1] however, shows that no Minoan or Mycenaean female statuette can be described as clasping her breasts. In all cases and in this statuette also the hands do not grasp the breasts but are held just before or just below them. If the hands in any case touch the breast, this is due to technical reasons and lack of skill on the part of the worker. In the Boston and Knossos figures the arms which are held straight out are made in separate pieces and attached so that the difficulty of undercutting is avoided. In this case the arms are not undercut, and therefore their contact with the bosom is due to technical reasons. We have then no criterion for deciding whether the figure is a goddess or a votary except the fact that the costume is more like that of the faience votary from Knossos than like that of the Snake Goddesses themselves, and this figure carries no snakes like the Knossos, Boston, and Berlin figures. So pending further evidence and research we may call the Fitzwilliam statuette a votary like the Knossian faience figurine and suggest that it formed part of a cult group from a shrine which had been destroyed by fire.

Still the name we give to this statuette in no way affects its artistic and archaeological importance. Its bearing on the costume of the age has been fully treated above; its artistic qualities are selfevident in physical beauty, aesthetic feeling, and technical skill. The poise and attitude are superb and the contrast between the formalism of the dress and the lifelike modelling of the arms and breasts indicates that such a figure is the outcome of long centuries of apprenticeship in the plastic arts. The face is characterised by a noble sympathy, the whole conception is devout, and the grace of the slender hand and fingers reveals the touch of a master. This, for we can exclude

[1] *op. cit.*, pp. 253, 340, 1; his exception of this statuette is due to a misunderstanding.

as technically different the figurines of terracotta or faience and the bas-reliefs in steatite, ranks as the earliest piece of true sculpture in stone[1] yet found on Greek soil, and is, if it is to be dated to Late Minoan I, almost two centuries older than the Lion Gate of Mycenae. There is between them a great stylistic gulf. This statuette shows the delicate craftsmanship of a mature and refined culture, while the lions of Mycenae, equally well rendered anatomically, show breadth and strength. The one typifies a palace decorated by the ingenuity of a Daedalus, the other a fortress of a King of Men.

[1] The primitive marble statuettes of the Cyclades cannot be taken into artistic comparison.

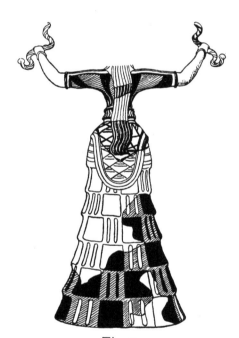

Fig. 2.
Faience Statuette of Votary
from Knossos.
(Scale *c.* 1 : 3.)

INDEX

Agia Triada, fresco of seated woman, 15, date, 43, description, 20, 21, 23, designs, 20, 21, 31, divided skirt effect, 20, 21, flounce arrangement, 23, 43, multiple skirt theory, 38; Sarcophagus from, 22.

Applied Metal, 31, 33.

Appliqué, 30, 31.

Apron, of Boston Snake Goddess, 20; Fitzwilliam Statuette, 9, 11, 38; Knossos Snake Goddess, 11, 16, 30; Knossos Votary, 11, 17, 31; Second Votary, 18.

Astypalaea, comparison of costumes with Minoan, 38.

Base, provision for placing statuette upon, 5.

Beading, on binding of hat of Fitzwilliam Statuette, 9, 38.

Beads, use on headdress, 38.

Beadwork, as decoration on garments and hair, 29, 31, 33.

Bell-shape, cut of skirt, 10, 15, 17, 18, 19, 20, 22, 38; terracottas, 43.

Belt, of Agia Triada woman, 20; Boston Snake Goddess, 19, 37; Fitzwilliam Statuette, 3, 11, 37; Princess from Dendra, 11, 37; Rameses III, 11, 29, 30, 31, 37; Theban women, 21; Tirynthian women, 22; Votary, 17; Second Votary, 18; Votive Dresses, 18, 19. See also Sash.

Berlin, Snake Goddess at, as stage in evolution of costume, 39; date, 43; description, 20; sash and skirt, 15.

Bias, use in apron, 11, in skirt of Agia Triada woman, 21.

Binding, on Fitzwilliam Statuette, apron, 38, hat, 9, sleeves, 9; on Boston Snake Goddess, flounces and sleeves, 19, 20, 32; on Votive Dresses, 18.

Boar's tusks, possible use in bodice fastening, 10; on Homeric helmets, 37.

Bodice, of Agia Triada woman, 20; Berlin Snake Goddess, 20; Boston Snake Goddess, 19; Fitzwilliam Statuette, 9; Knossos Snake Goddess, 16; Mycenae rings, 23; Petsophas women, 15; Theban women, 21; Tirynthian women, 21, 22; Votary, 17; Second Votary, 18; Votive Dresses, 18.

"Bones," use in stiffening bodice, of Boston Snake Goddess, 19, 32, of Fitzwilliam Statuette, 9, of Knossos Snake Goddess, 16, of Votary, 17.

Boston, Snake Goddess at, 4, 15; arm position, 44; belt, 37; bodice, 23; construction, 4; date, 43; description, 19 f.; flounce arrangement, 43; materials of costume, 32, 33; multiple skirt theory applied to, 38; subject, 44.

Braid, 9, 31, 32, 37.

Bronze, possible use for "bones," 9; possible use in bodice fastening, 10.

Brooch, as bodice fastening, 9.

Buckle, as bodice fastening, 9, 10.

Button, as bodice fastening, 9.

Candia, as provenance of Fitzwilliam Statuette, 3.

Cap, on Fitzwilliam Statuette, 15; Knossos Snake Goddess, 16; Petsophas figurine, 15. See also Hat and Headdress.

Caskey, L. D., on Mackenzie's theory of costume, 38.

Chemise, Evans' theory, 39.

Chisel, use in making Fitzwilliam Statuette, 3.

Chryselephantine, see Boston Snake Goddess.

Circlet, 17, 19.

Clasp, as bodice fastening, 10.

Clay, use in joining Fitzwilliam Statuette, 3; base of, from Palaikastro, 5.

Collar, Medici, on Petsophas figurines, 15.

Cording, on skirts of Boston Snake Goddess, 19, 20, Fitzwilliam Statuette, 10, Knossos Snake Goddess, 30, Votary, 17, 31, Second Votary, 18, Votive Dresses, 18, 31.

Coroplasts, technique in figurines, 4.

Corsets, of iron, Europe XVIIth century, 9.

For EU product safety concerns, contact us at Calle de José Abascal, 56–1°,
28003 Madrid, Spain or eugpsr@cambridge.org.

www.ingramcontent.com/pod-product-compliance
Ingram Content Group UK Ltd.
Pitfield, Milton Keynes, MK11 3LW, UK
UKHW051030150625

459647UK00023B/2873